WELCOME TO THE SKETCHB[OOK]

 IN 2006 ▶ *two friends from art school sent out a call for sketchbooks to take on tour across America in a traveling library.*

IN 2006
544
artists submitted their sketchbooks.

BY 2012
61,789
artists participated.

In
2009
1,200
SKETCHBOOKS
were stored in the
BROOKLYN ART LIBRARY.

In
2012
22,187
SKETCHBOOKS
were stored in the
BROOKLYN ART LIBRARY.

You can check out thousands of digitized sketchbooks online at www.arthousecoop.com/library.

IN 2011
there were
332,501
views of the
DIGITAL LIBRARY.

IN 2012
there were
1,103,449
views of the
DIGITAL LIBRARY.

IN 2006 *the Sketchbook Project went global.*

IN 2006 *artists from*
15 COUNTRIES
around the world participated.

IN 2012 *artists from*
130 COUNTRIES
around the world participated.

This journal includes more than 327 prompts to help you get started. We hope you'll feel inspired to keep creating when you're done!

STEVEN PETERMAN & SHANE ZUCKER

Creators of the Sketchbook Project

**RIP THIS PAGE OUT AND CREATE SOMETHING FOR
A STRANGER TO FIND**

To begin, please select:

☐ **THIS IS A SKETCHBOOK**

☐ **THIS IS NOT A SKETCHBOOK**

DRAW THE FIRST THING YOU SEE IN THE MORNING . . .

When your eyes are still closed

Upside down (don't fall out of the bed)

In less than thirty seconds

With your nondominant hand (that's asking a lot before breakfast)

START

●

THE SCIENCE OF STORY

Foot notes

The table and its contents

Remove the appendix

Move the foreword backwards

That book has no spine

Take cover!

Around the text block

This book lacks dedication

WE SWEAR THESE ARE ALL REAL COLOR NAMES

Castaneous

Glaucous

Eau-de-Nil

Cinnabar

Bazaar

Byzantium

Carmine	*Malachite*	*Rajah*
Xanadu	*Zaffre*	*Aurulent*

CREATE SOMETHING HIDEOUS

TAKE A MOMENT TO REMEMBER WHEN WE WERE ALL KIDS . . .

Water slides I never rode

Capture the flag

Swings and monkey bars

Show-and-tell

Your childhood friends

WHEN YOU COMPLETE THE NEXT PAGE, CONNECT THE STITCHES TO CREATE A CONSTELLATION

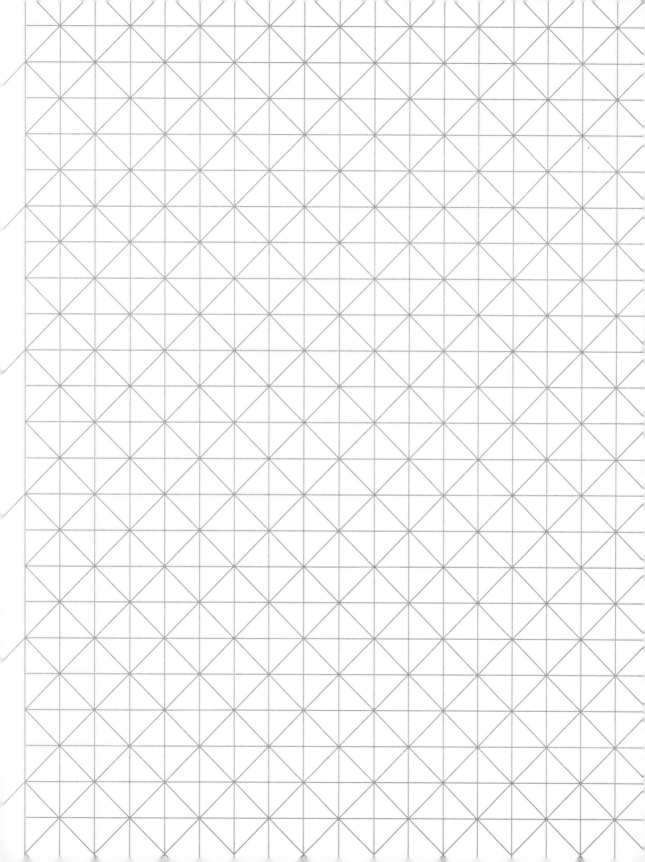

USE THE STITCHES FROM THE REVERSE PAGE TO CREATE A COMPLETELY NEW PATTERN

Almost done

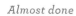

Over done

IT'S BEEN A LONG DAY. LET'S TAKE A MOMENT TO REFLECT:

What did you do seventeen days ago?

Anything eventful happen on Tuesday?

What about last Thursday at 5:23 p.m.?

And, if you were awake, what about 4:23 this morning?

DEEP INSIDE THE CENTER OF THE EARTH IS A TINY...

A really "shady" tree house

A hermit's hovel

A cabin in the middle of the woods

A solitary bunker

FORKS

SPOONS

FIGURE OUT THESE CRAZY SHAPES

Arbelos

Triquetra

Tomoe

Rhomboid

Decagram

Lune

Hendecagon

Heptagram

EVERYONE I HAVE EVER MET...

. . . AND THE STORIES THEY TELL

DIAGRAM TIME!

A perfectly proportioned sandwich

My teenage brain

A horrible hotel room

My childhood home

The tallest building in town

The stars in the night sky

Outside assignment: Create a 3-D diorama from your diagram

CUT OUT THIS ENVELOPE AND MAIL IT TO SOMEONE YOU HAVEN'T SPOKEN TO IN A WHILE

Cut me out and fold me ⟶

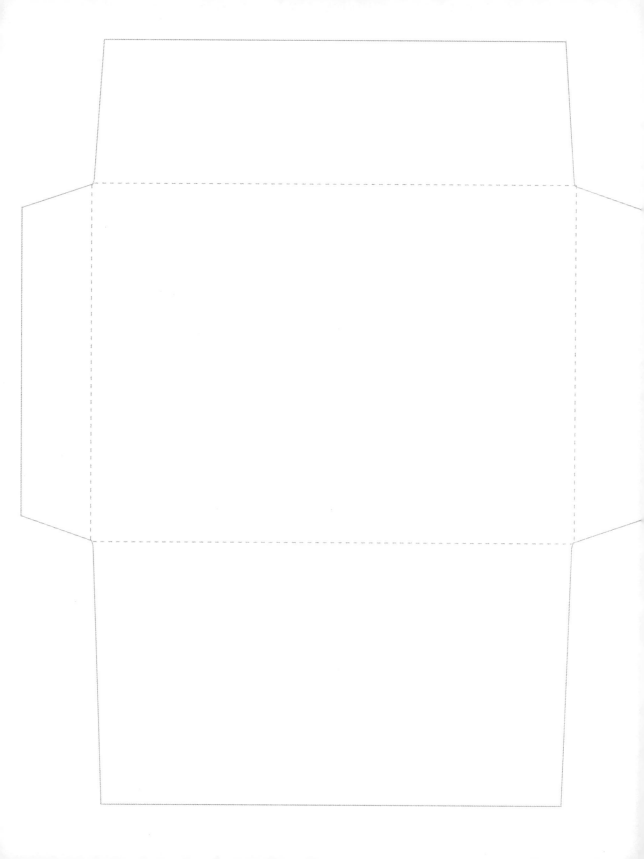

IMAGINE THE VIEW FROM . . .

A boat lost at sea

The window seat on a transatlantic flight

A really tall mountaintop

The edge of the forest

FILL ME WITH STORIES

Help! Robots are attacking the local public library!

Help! The cucumber factory is in a pickle!

Help! A zombie asked me to the prom!

Help! The strawberry farm is in a jam!

SCIENCE PROJECTS GONE WRONG

An animal hybrid

Loss of eyebrows

How many fingers did I originally have?

A slightly imperfect clone

Your favorite place to hide

Dreams of running to a far-off land

Your earliest memory

An adventure you took

SUPERHEROES IN EVERYDAY CLOTHES

RIGHT/WRITE WHEN YOU GET THERE

Scribble

Color

Scratch

Dot

Smudge

STITCHES AND FOLDS *Fold and stitch these pages along the dotted lines*

ABOVE THE FOLD

UNDER THE FOLD

THINGS FOUND

On restaurant napkins

Under car seats

In your refrigerator

In between

In your wallet

In the laundry

By accident

Too late

A MONSTER THROUGH THE LENS OF A CAMERA

Fisheye

Panoramic

Wide angle

Telephoto

SKETCH ALL THE PEOPLE YOU SAW TODAY

CREATE A SECRET CODE

AND THE KEY

**USE THESE PAGES TO DESCRIBE YOUR PLAN TO SURVIVE
THE END OF THE WORLD**

ON A SHELF

IN A DRAWER

QUIT BUGGING ME

The spider caught me in his web

The bee caught me in a sting

That ant is my uncle!

That moth borrowed my sweater

MYSTERY MAPS

Underground tunnels

Between your house and mine

Sand castles

Attics to basements

Mall of the future

Abandoned amusement park

To your buried treasure (please submit all
treasure maps to the Sketchbook Project)

SNOBS

MOBS

PLEASE SUBMIT THE FOLLOWING:

A letter of recommendation

A picture of hope

A moment in time

The contents of your pockets

AN EXPEDITION OF SORTS

To the moon

Traversing between the trees

An excursion across the plains

An air flight home

Lost in the open desert

A jog in the jungle

A hunt through the Himalayas

Meet me in outer space

JACKETS, BLANKETS, AND SHEETS

SKETCH THESE SNIPPETS OF OVERHEARD CONVERSATIONS

I think I have one too many cats

I think I ate too many hot dogs

I think I forgot something

I think I should not have made that comment

CREATE A PUZZLE

Where you are, in one hundred years

Past, present, and future

Great hopes and massive failures of the past

Draw your house in two hundred years

Interfere with a historical moment

Steal designs for the next great invention

WELCOME TO PAGE 84 . . .

AND 85. GRAB A PEN AND MAKE A LINE UNTIL THE INK RUNS OUT.

Shoelaces

Fifteen sea lions

A surfboard

A flat can of soda

Rubber bands

Sixteen buttons

One rake

Forty-five lawn gnomes

WRITE ONE ANECDOTE A DAY FOR THE MONTH

SUNDAY	MONDAY	TUESDAY	WEDNESDAY	THURSDAY	FRIDAY	SATURDAY

THIS LIST

Will save your life

Is for my eyes only

Will capture the moment

Is long overdue

Is just a form of procrastination

Must be destroyed

Is full of doodles

Will self-destruct in ten seconds

FRIENDS OF FRIENDS

(Paste photos, draw, or create a diagram of all your friends and their friends, and their friends)

ALL THINGS COME TO AN END

A stump

A relationship

A conversation

A ledge

I KNOW YOU HAVEN'T KNOWN EACH OTHER LONG, BUT THE BOOK WANTS TO KNOW, "DO YOU LIKE ME?"

Yes

No

I'm in the middle of another book right now

(CIRCLE ONE!)

Oh, OK . . . now draw a picture of the book's broken heart

PHOTOS

The photograph that changed the world

Captured in time

Over/underexposed

Digitally altered

One too many filters

A collage of one hundred photographs

A family portrait

Who is that guy in the background?

WHAT'S GOING ON IN THE LEFT SIDE OF THE BRAIN?

WHAT ABOUT THE RIGHT SIDE OF THE BRAIN?

IF I START HERE . . .

Cut slits into this page along the dotted lines

WEFT

WHERE WILL I END?

Cat

Dog

Leaping lizard

Dairy cow

Armadillo

Stingray

Electric eel

Flying squirrel

Twenty-pound rat

A cardiologist stole my heart

A vampire stole my blood

A cactus stole my water

A pigeon stole my letter

NOBODY PANIC!

EVERYBODY RUN!

THE SECRET AND HOW TO TELL IT

TRANSPORTATION

Dirigibles and submersibles

Our ships crossed in the night

Upon boarding this train

Whirlybirds

Panel vans

Paper airplanes

Flying carpets

HELP! WE NEED A TIME MACHINE AT THE LOCAL ELEMENTARY SCHOOL!

Chronicle a day

The deli picked my lox

My bagel got creamed

This matzoh is having a ball

Potato pancakes and waffles

ALPHABET LETTERS

LOVE LETTERS

Outside assignment: Send a love letter to your favorite person

I THINK IT WAS A RECORD YEAR FOR RAINFALL

CONNECT THE DOTS TO FIND A SURPRISE! (IT'S A DINOSAUR.)

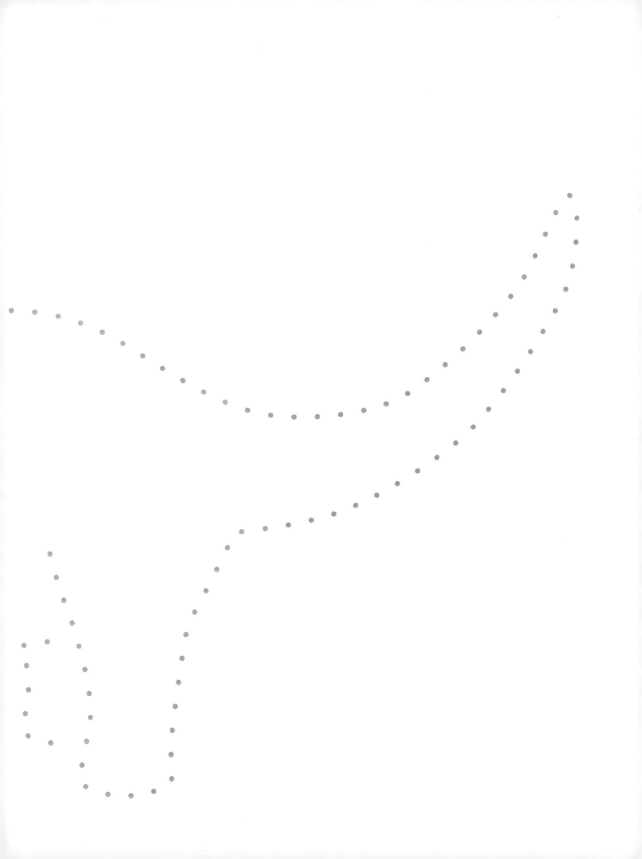

ARRIVAL

DEPARTURE

A mission

A hazard

A venture

A speculation

SOMETHING THAT WILL MELT

SOMETHING MADE OF FELT

OVER

UNDER

THE LAST DAY . . .

Of the year

I lied

We were friends

I can really remember

ZOMBIE THEME PARK

CREATE AN ENCYCLOPEDIA OF . . .

Smells

Sounds

Things under your bed

Objects on your desk

Neighborhood pets

New York City wildlife

Tools you don't know how to use

Dance moves

FAMILIAR

FOREIGN

CREATE SCENES FOR THE FOLLOWING WARNINGS

The seat belt light is on

Beware

Slippery when wet

Incline ahead

DITCHED

SOMETHING "BORROWED"

The shark "borrowed" my leg

The bear "borrowed" my picnic basket

The burglar "borrowed" my jewelry

That stranger is "borrowing" my car

A LETTER TO HOME

A LETTER TO A STRANGER

IN THE MIDDLE OF NOWHERE

USE THIS PAGE TO CREATE AN INVENTION TO MAKE
YOUR LIFE EASIER

A ROBOT ON A DATE

TOGETHER . . .

People are sleeping

People are hiding

People are running

People are confused

JET LAG

LAGGING JET

We drove till morning

You guys are going to wake up my mom

After curfew

Sleep (moon)walking

The unexpected outcome of last Thursday

How far can I get on $7.00?

AVOID

DISTANCE

INSIDE

A FOUND OBJECT

Discuss object

Investigate what it is

Inspect its surface

Consider its use

SOMETHING YOU WOULD INK

LIGHTS IN THE DISTANCE

A ship at sea

So you can find your way home

The North Star seems so far away

The glow of fireflies

Flashlight tag

DRAW YOUR WEAPON

THAT TREE

That tree is a sap

That tree is pining for me

That tree got spruced up

The tree read my palm

(LAST ENTRY HERE)